How to Draw

Unicorns

In Simple Steps

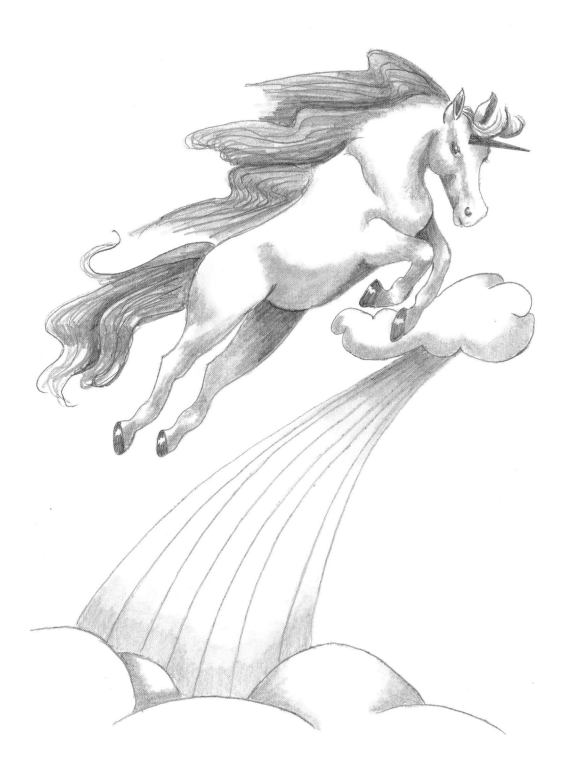

First published in 2020

Search Press Limited
Wellwood, North Farm Road,
Tunbridge Wells, Kent TN2 3DR

Reprinted 2021

ISBN: 978-1-78221-889-0

You are invited to visit the author's website:
www.sharonhurst.co.uk

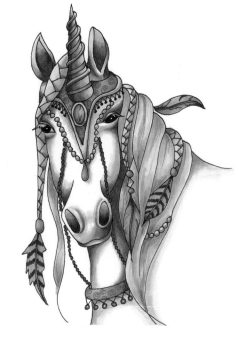

Dedication

For Emma, whose love of all things unicorn has kept the magic alive and inspired me to paint them in all their glory.

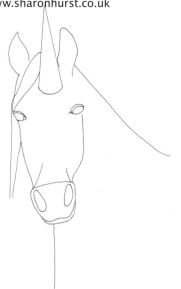

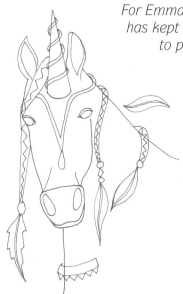

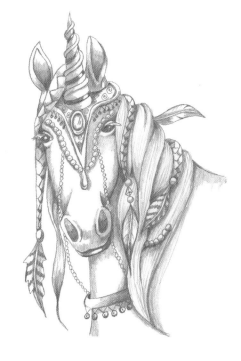

Illustrations

How to Draw
Unicorns

In Simple Steps
Sharon Hurst

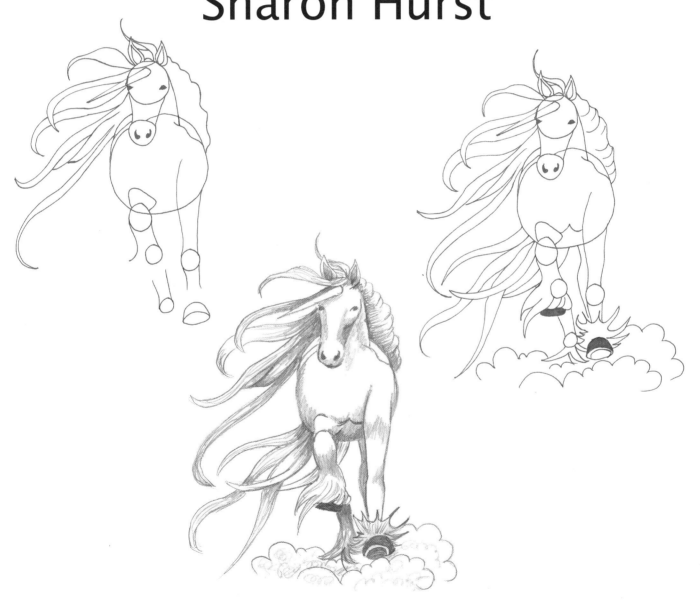

Search Press

Introduction

Welcome to the world of unicorns! Join me on a journey through the creation of these fantasy beasts. I have offered a broad assortment, so there will be something there for everyone. Some are very simple, so these would be a good place to start, and hopefully they will encourage you to develop your drawing abilities. As you feel more confident, work your way through and try some of the more complicated projects. You will soon be designing and creating your very own unicorns. All you need is to be young in spirit and have bundles of enthusiasm!

When I was a child, my grandmother was always telling me stories. She really fired my imagination and inspired my artwork. Nowadays I look to my friend, Emma, whose unfailing love for all things unicorn has ensured that our home is full of cushions, pictures, bath products and clothes, all covered in images of this legendary creature.

I have used a two-colour system, with lines in red and black. The lines you draw in each successive drawing are shown in red. Black is used for the parts that you have already drawn. I have done this to make it clear what you must do next – draw yours in black only. I have used simple shapes at the beginning and then refined them as the drawing develops to make the elements more realistic.

I used a 2B pencil. This is a good option as it is quite soft and shouldn't mark the paper too badly when you rub it out later. When you need to rub things out, use a soft eraser so that you don't damage the paper. When you are happy with your drawing, use a quality ink pen to go over your lines. Make sure it is waterproof and bleed-proof if you are going to use marker pens. Test it out first with water or a colour pen. Once you have inked it all in, you can use your eraser to make sure that you have no pencil lines left.

For colour, I used marker pens and for the unicorn with the galaxy eye, just a tiny touch of white pen (a gel/pigment ink hybrid) for highlights. Pens are quick, easy, clean and simple. Shading takes a bit of effort because you must repeatedly work one colour over another, but with a bit of practice you will get the hang of it. Use whatever medium you are comfortable with: try watercolours, acrylics, pencils or crayons. Enjoy adding colour and watch your picture come to life.

If you are not confident about your colouring abilities, you might like to colour your picture first and then use the pen to outline it. If you have had a 'bit of a wobble' when you are colouring or painting, you can use the pen to tighten up all your edges and neaten up your wonky bits!

In your future paintings, use the easy formula of looking for simple shapes such as circles and triangles to build up your picture. Like me, you can lay tracing paper over a photograph or sketch, draw the shapes in and then transfer it to your drawing. Work in stages as we have done throughout this book. You won't have to look very far to see horses in fields, on TV and in books and then you might want to improvise using nature for manes and horns. Look at leaves and twigs, clouds in the sky and even the fur on your pets at home. Now why didn't I think of a furry unicorn? Can you imagine it?!

Enjoy your drawing!

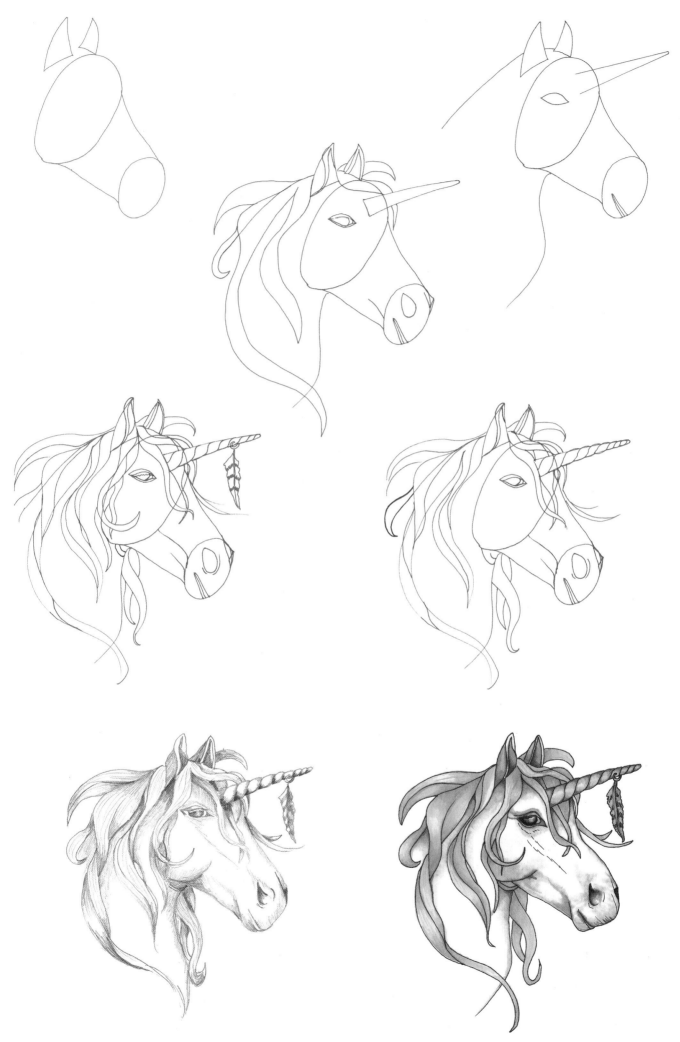

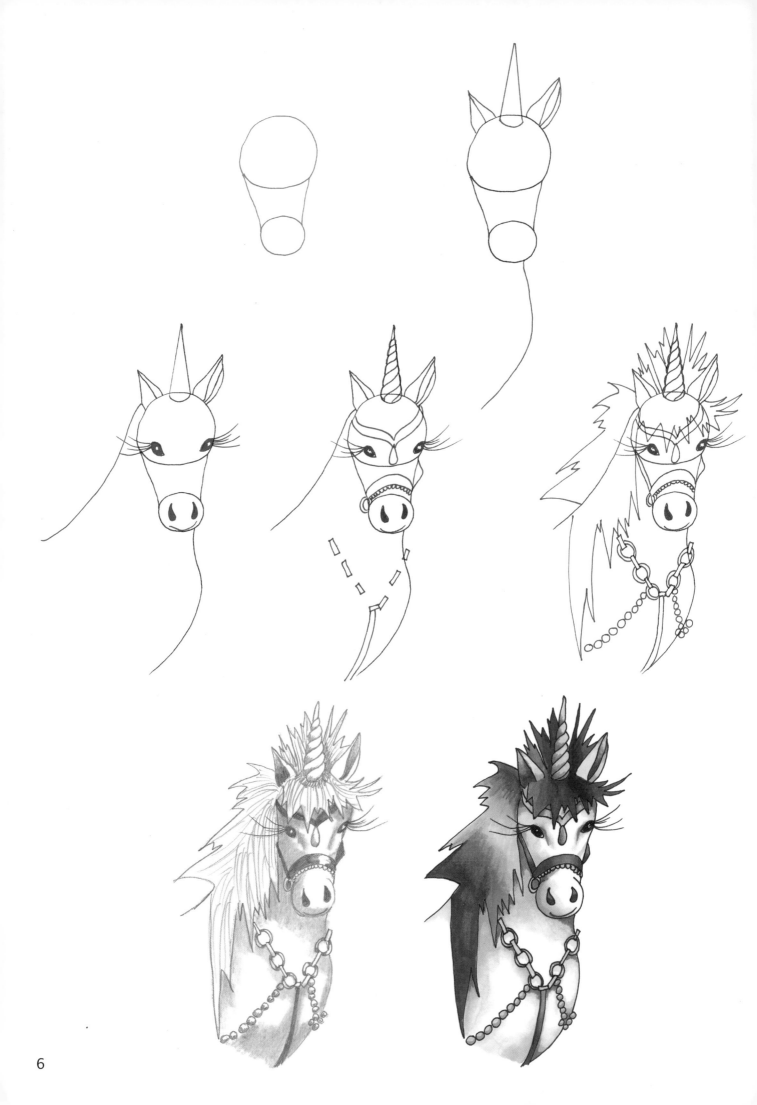

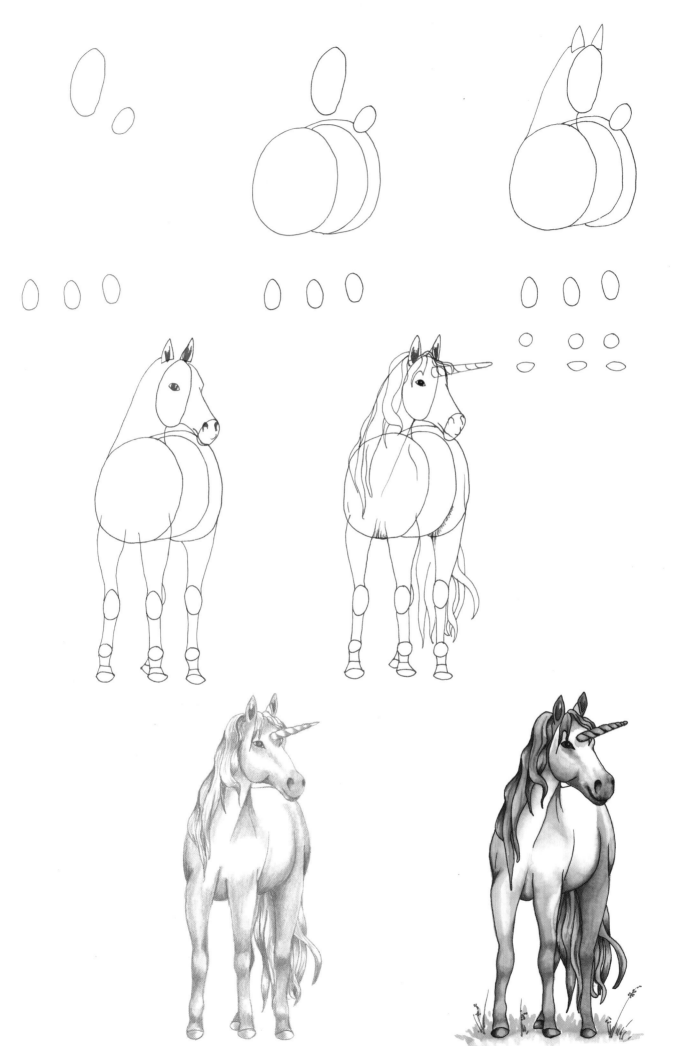

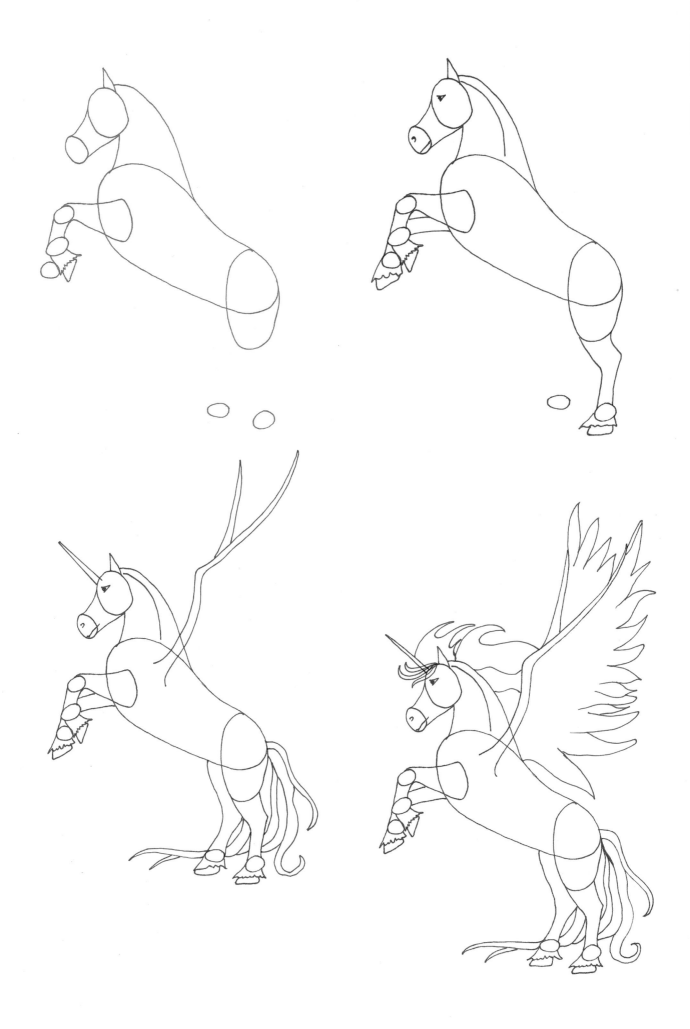

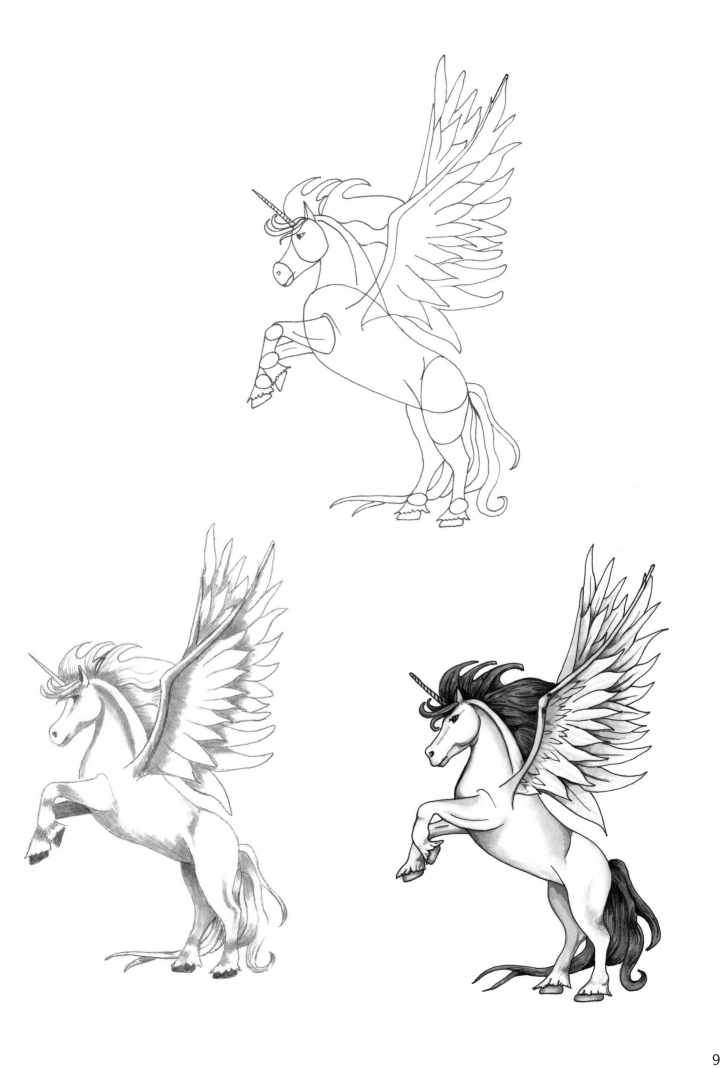

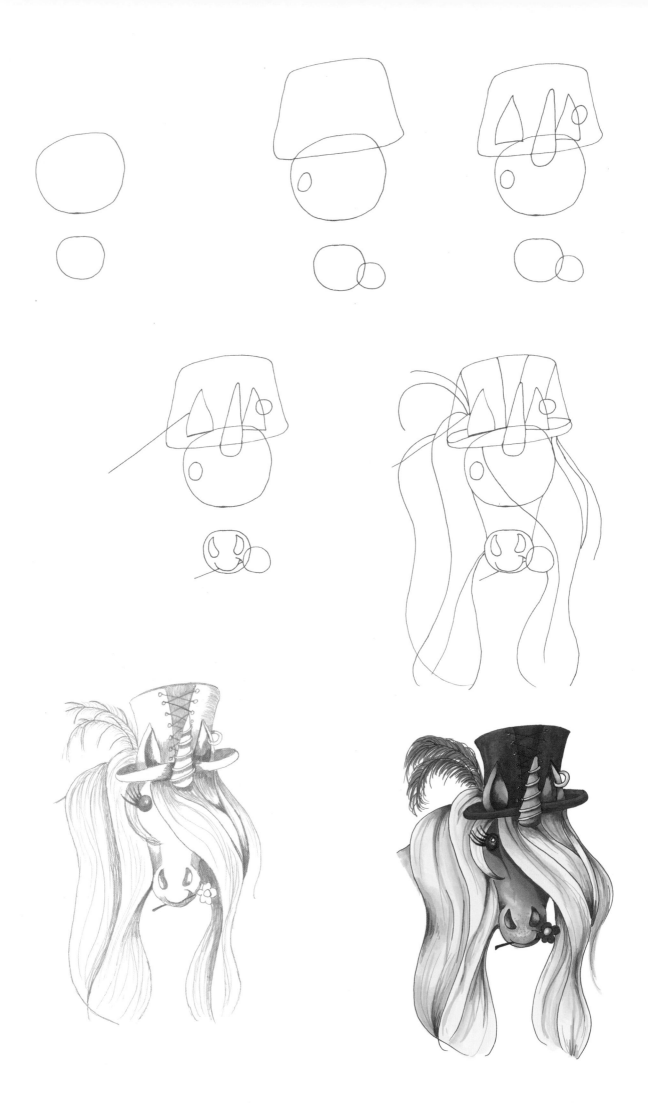

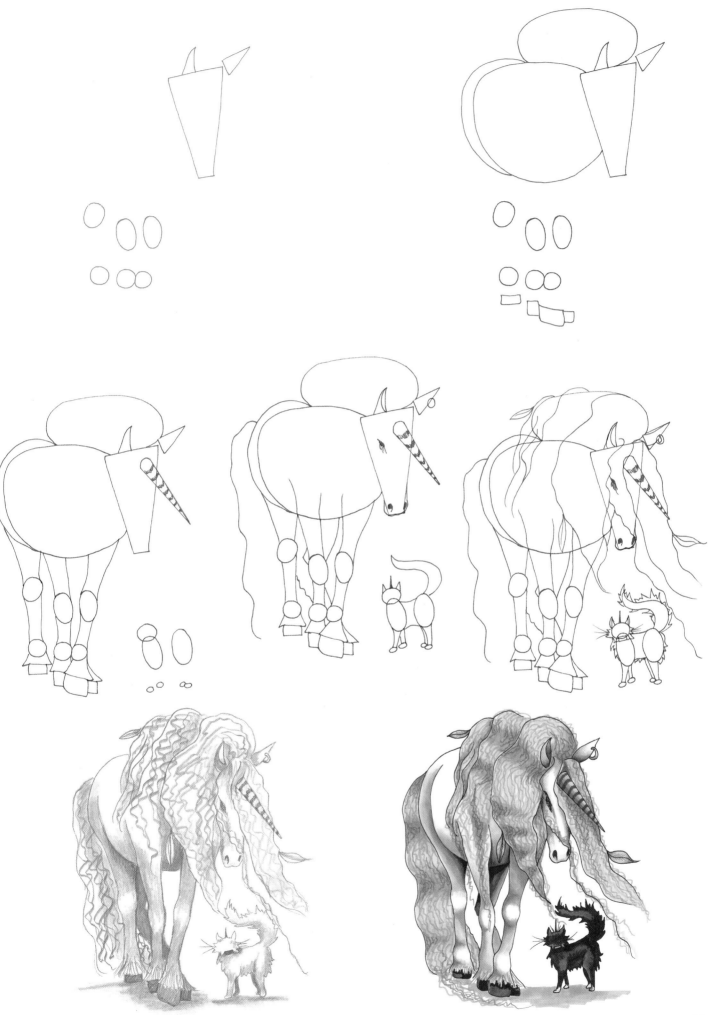

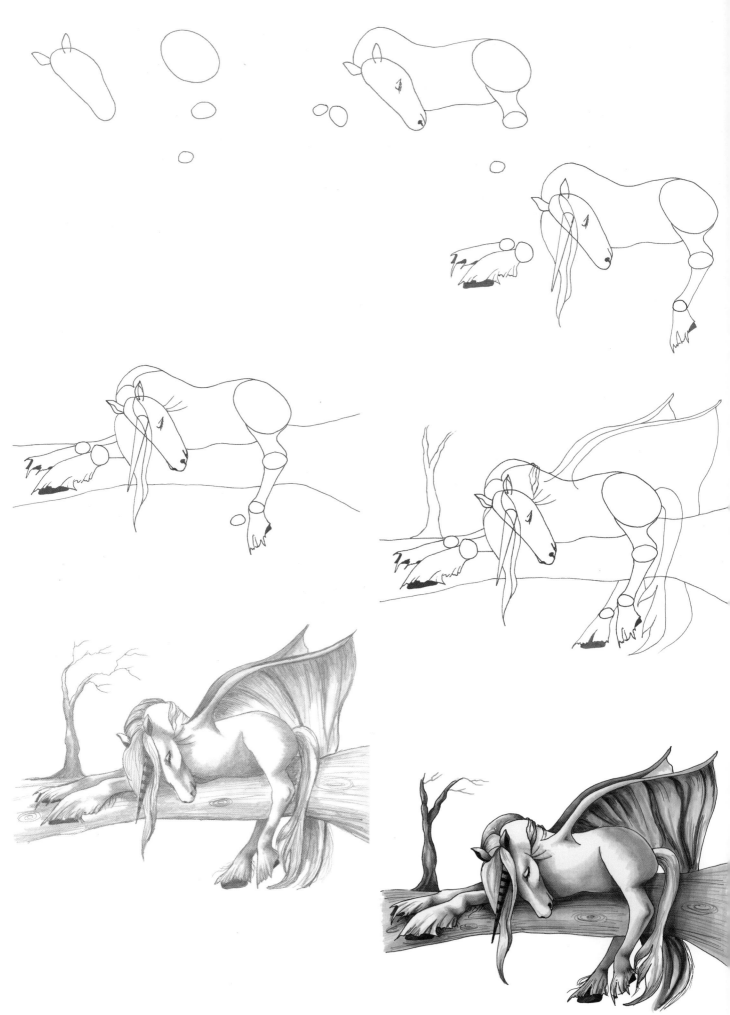

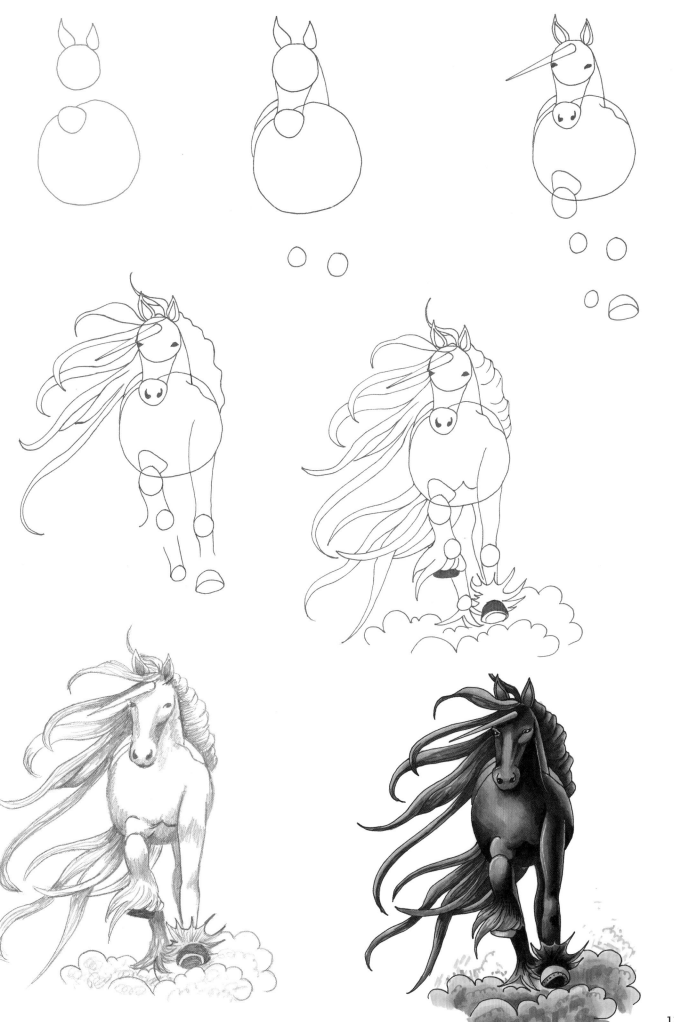

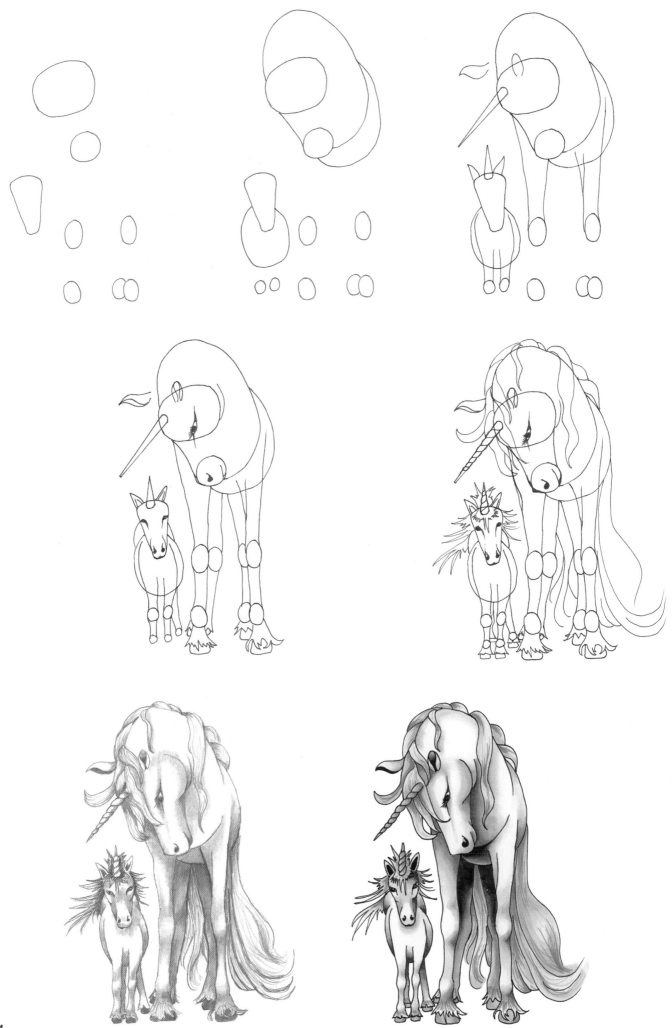

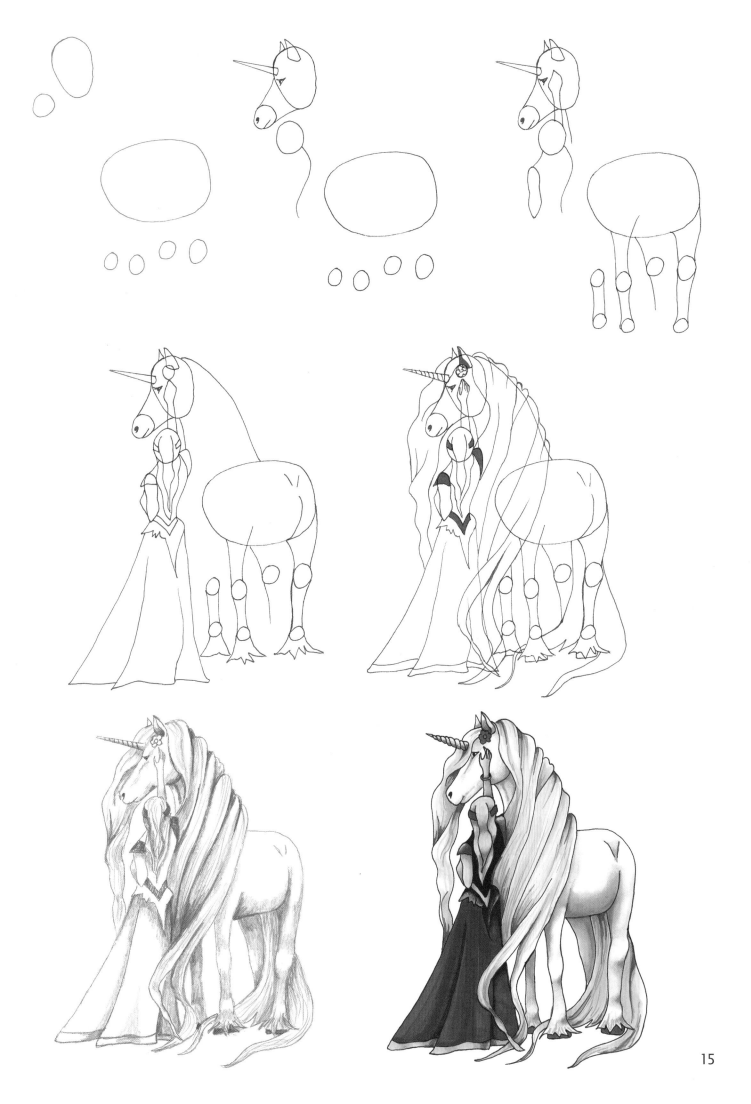

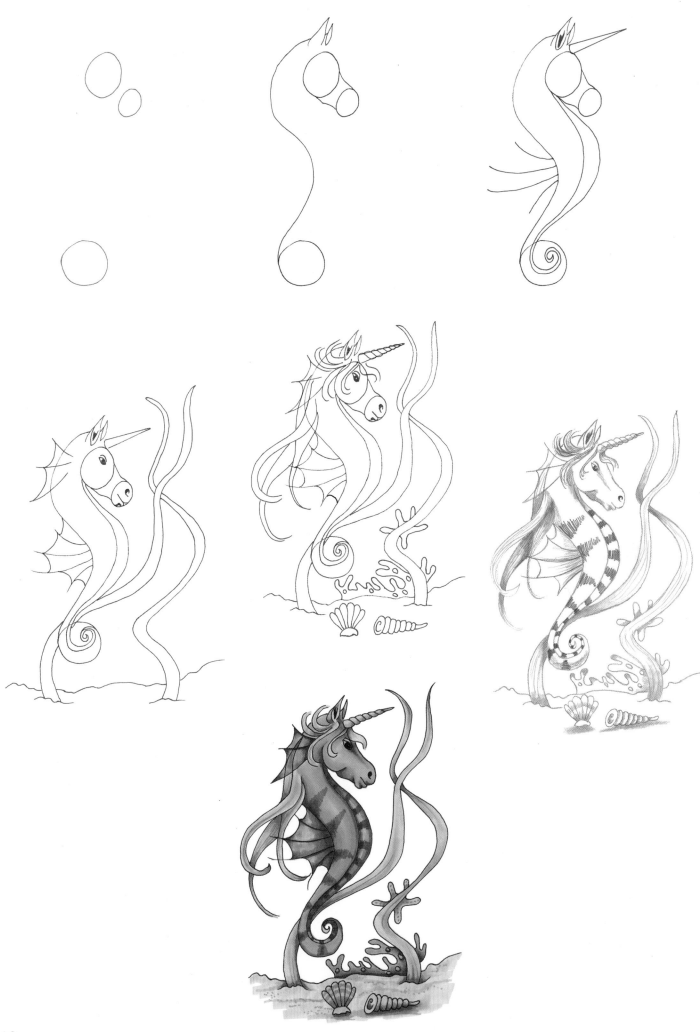

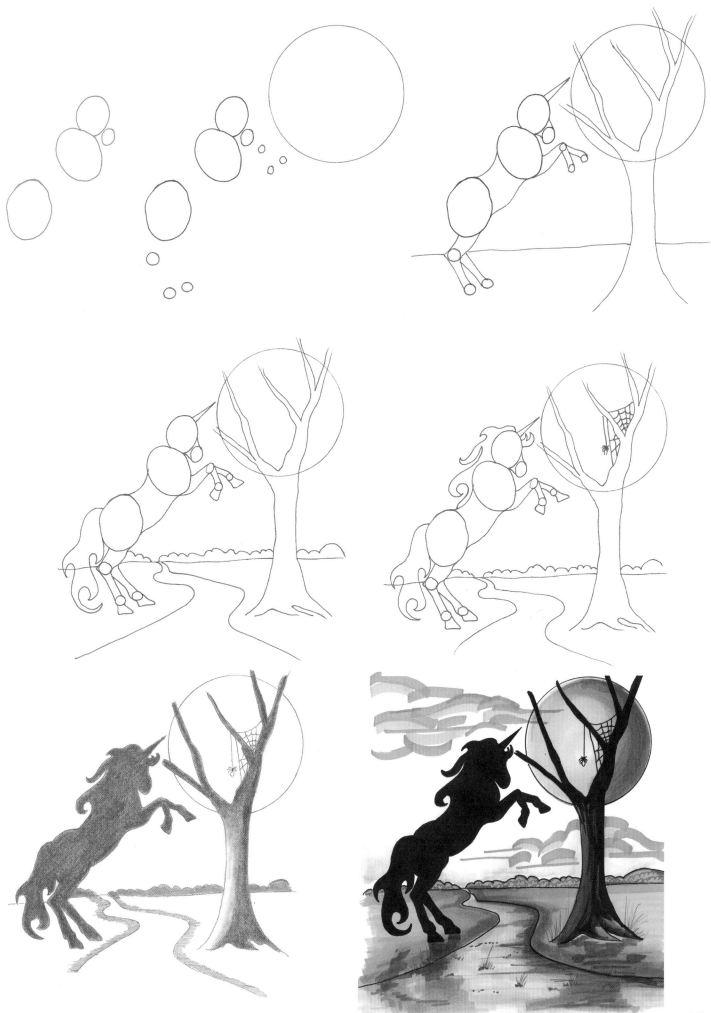

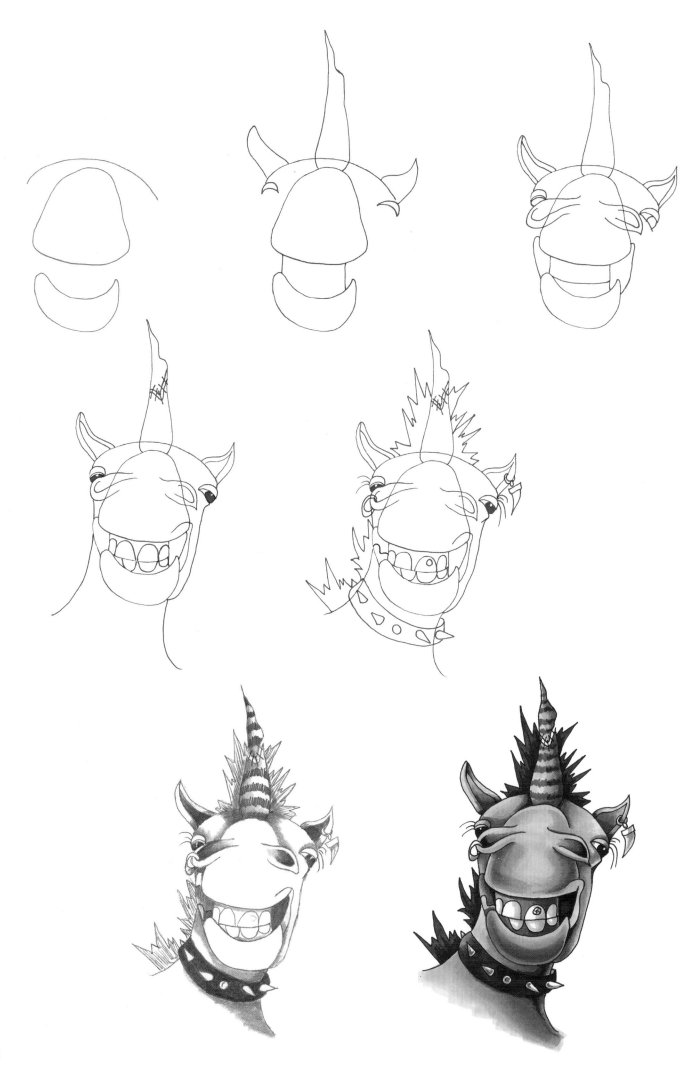

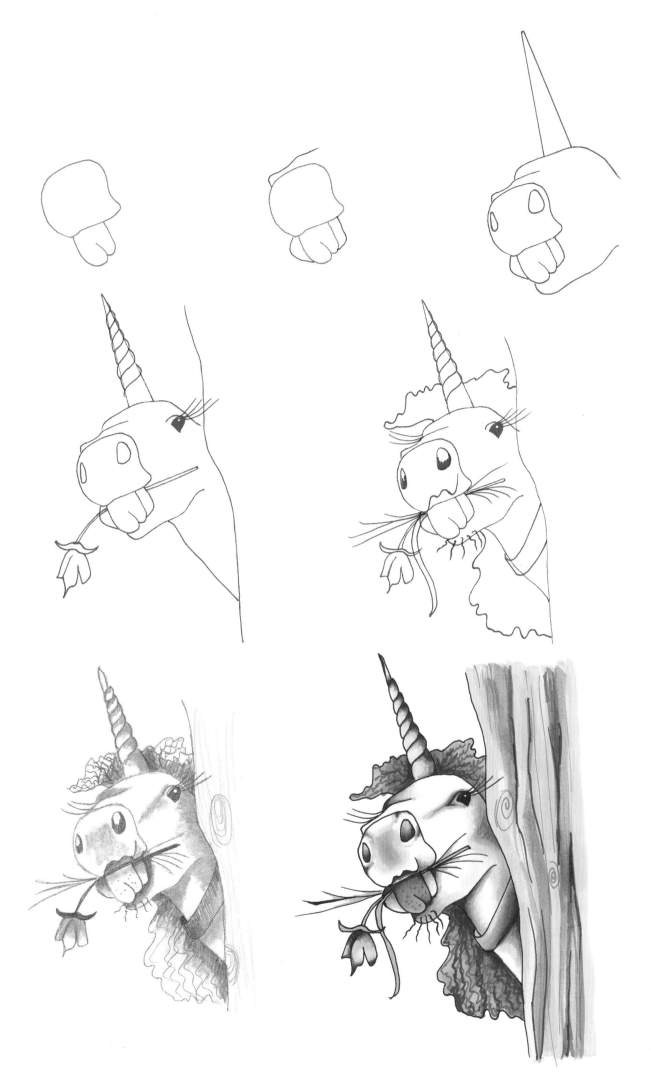

19

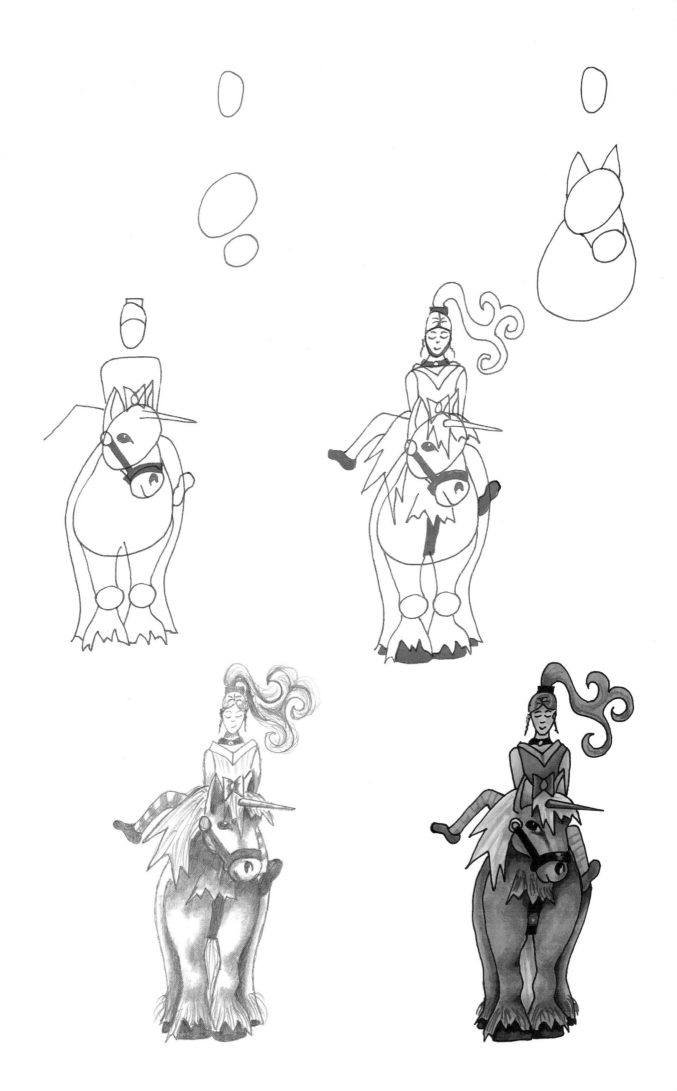

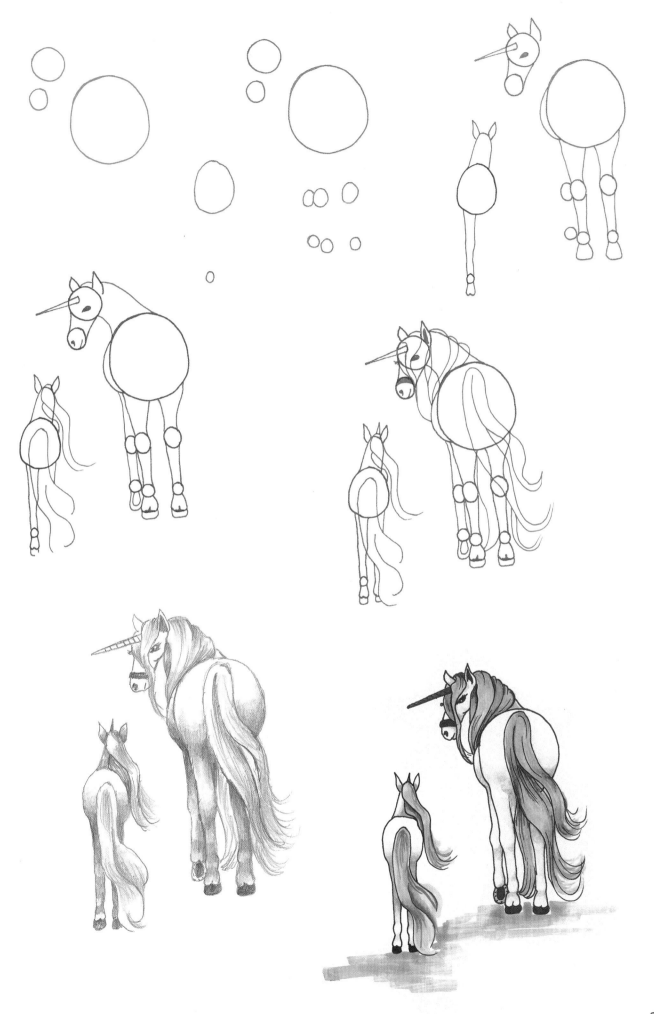

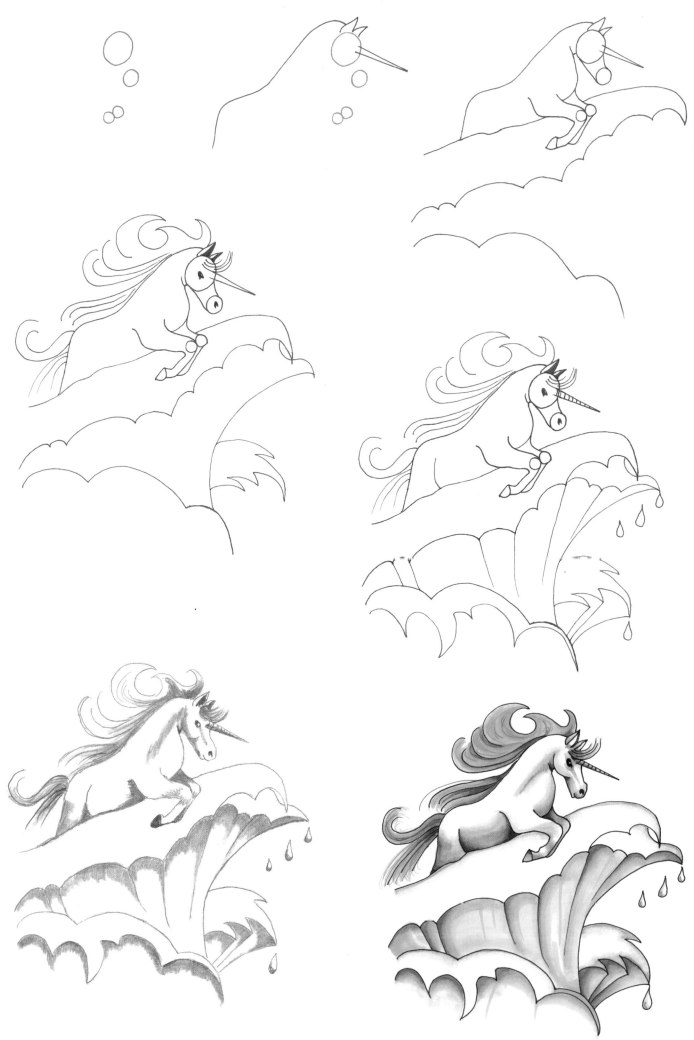

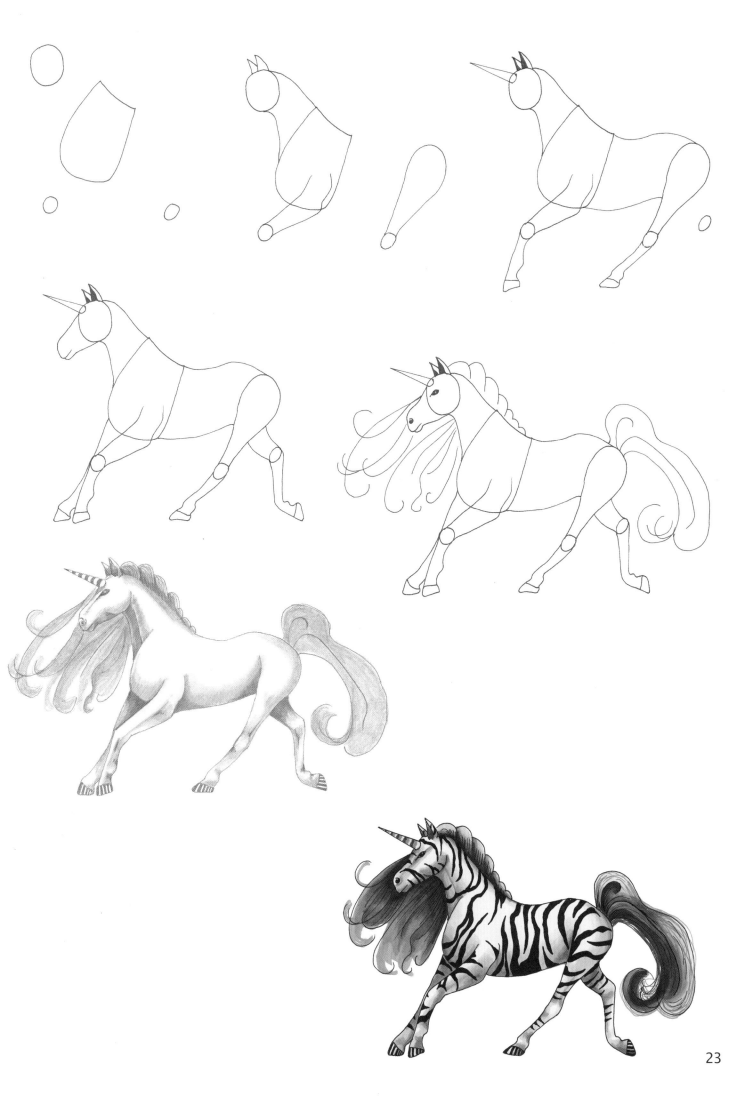

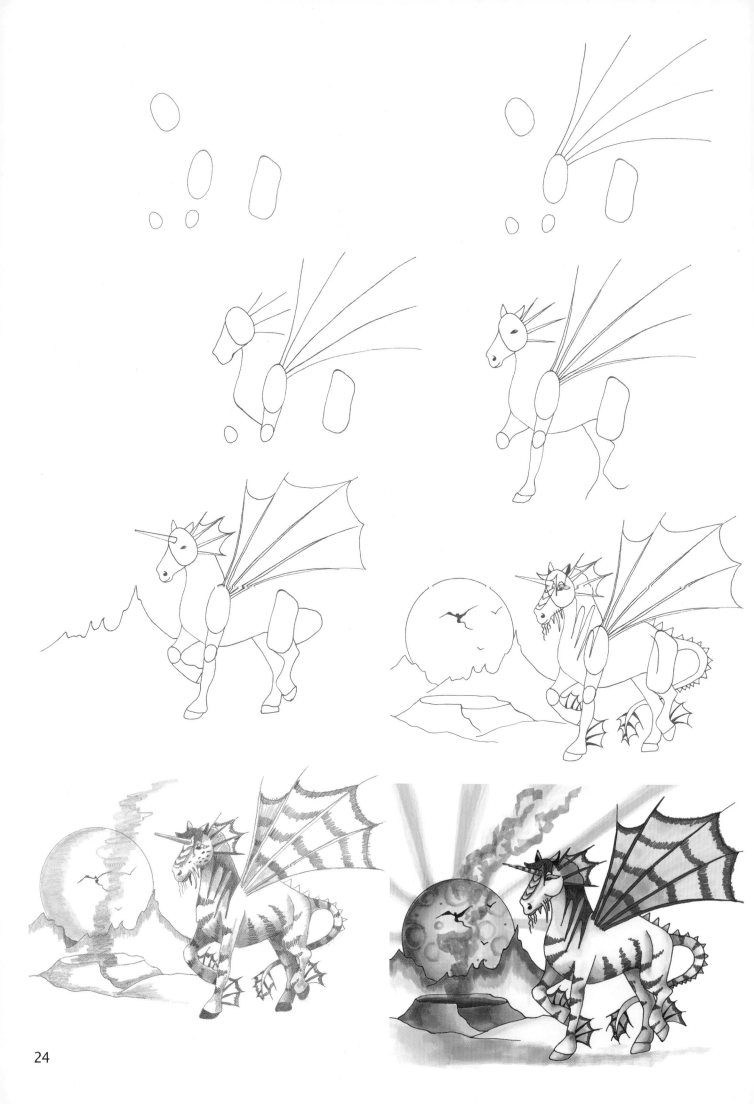

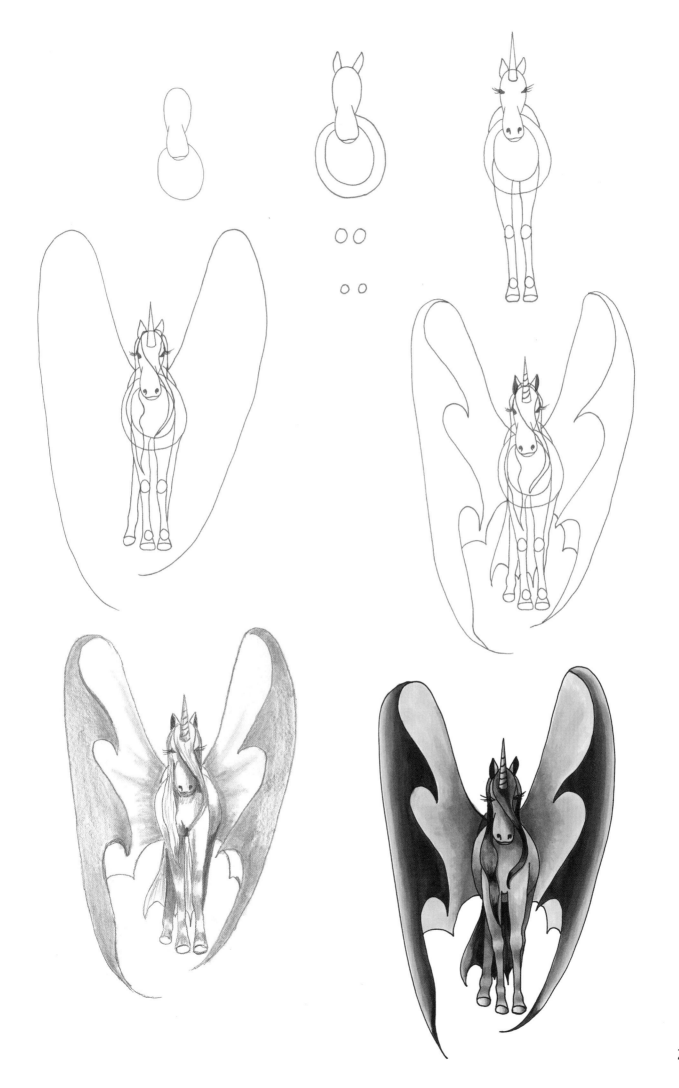

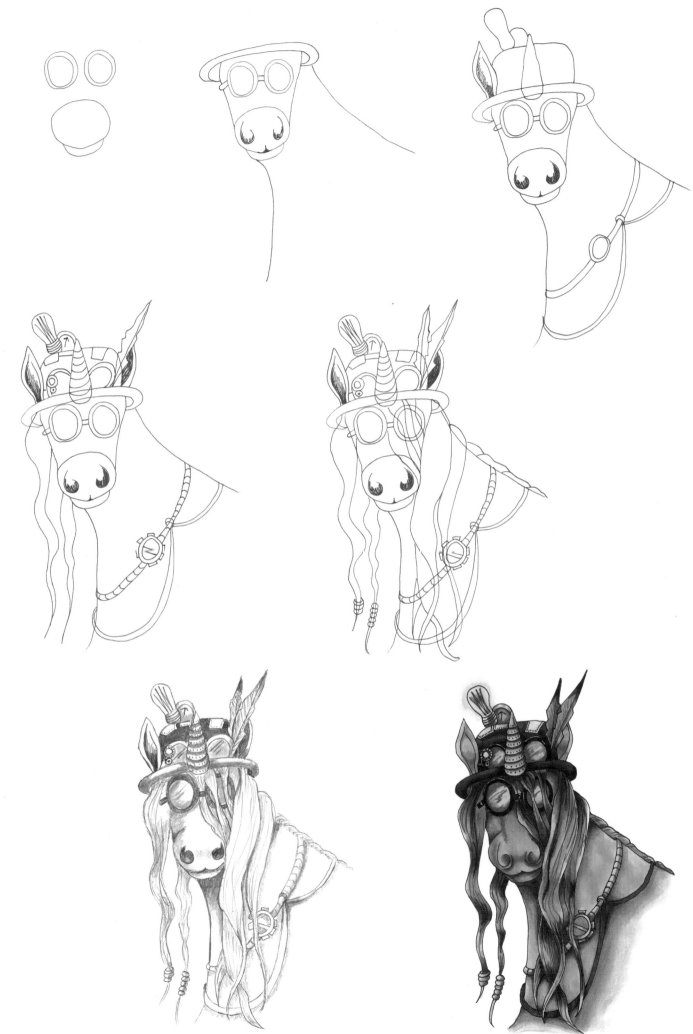

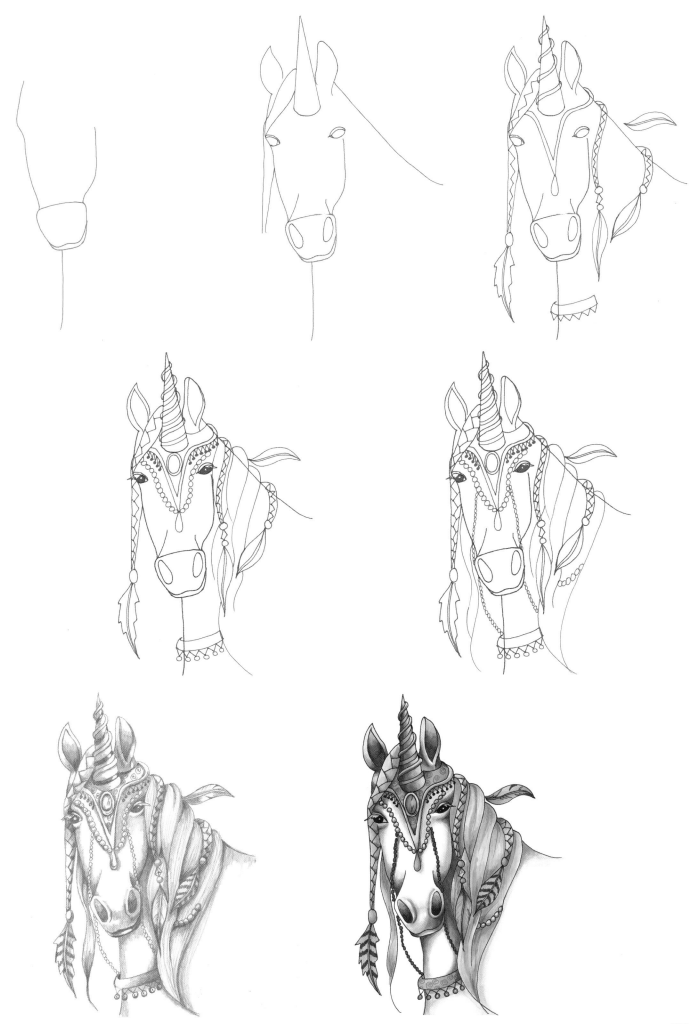

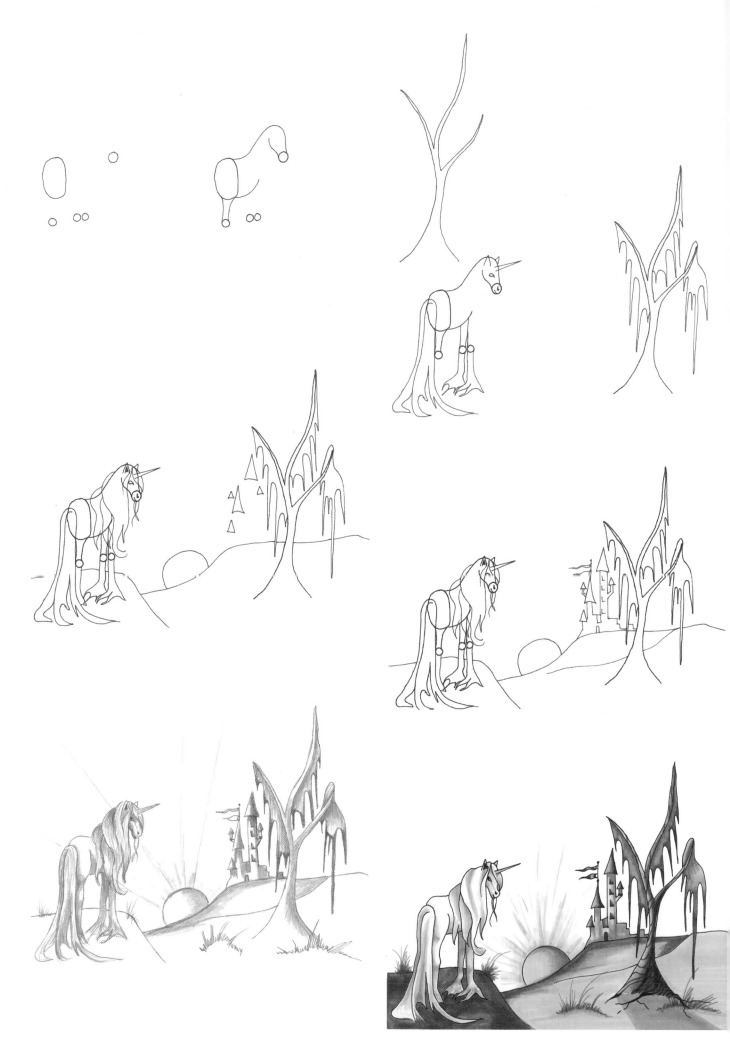

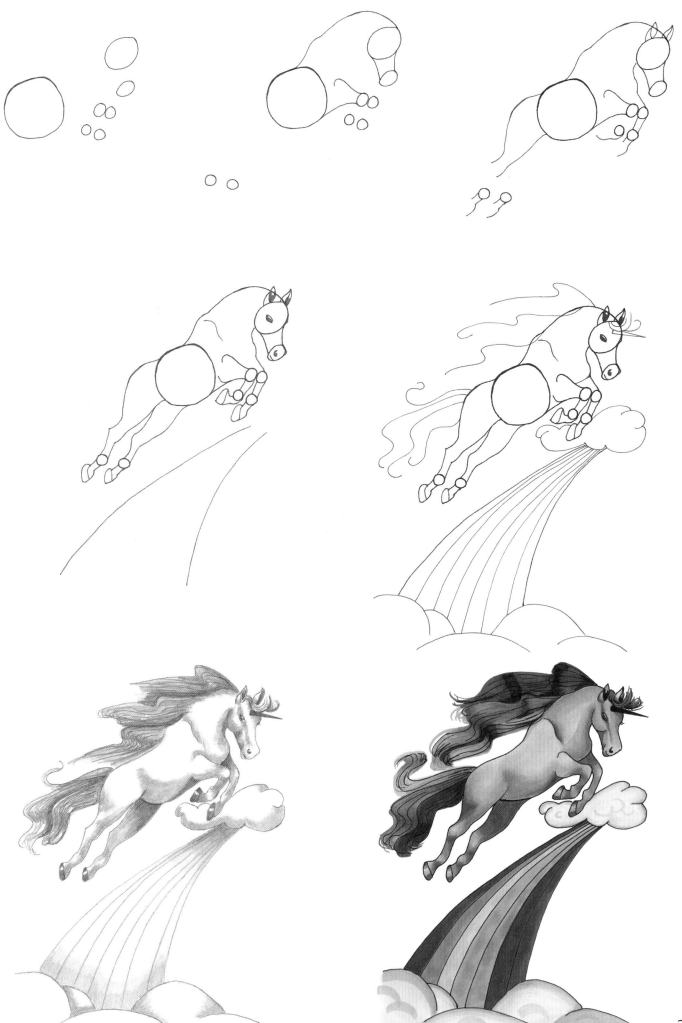

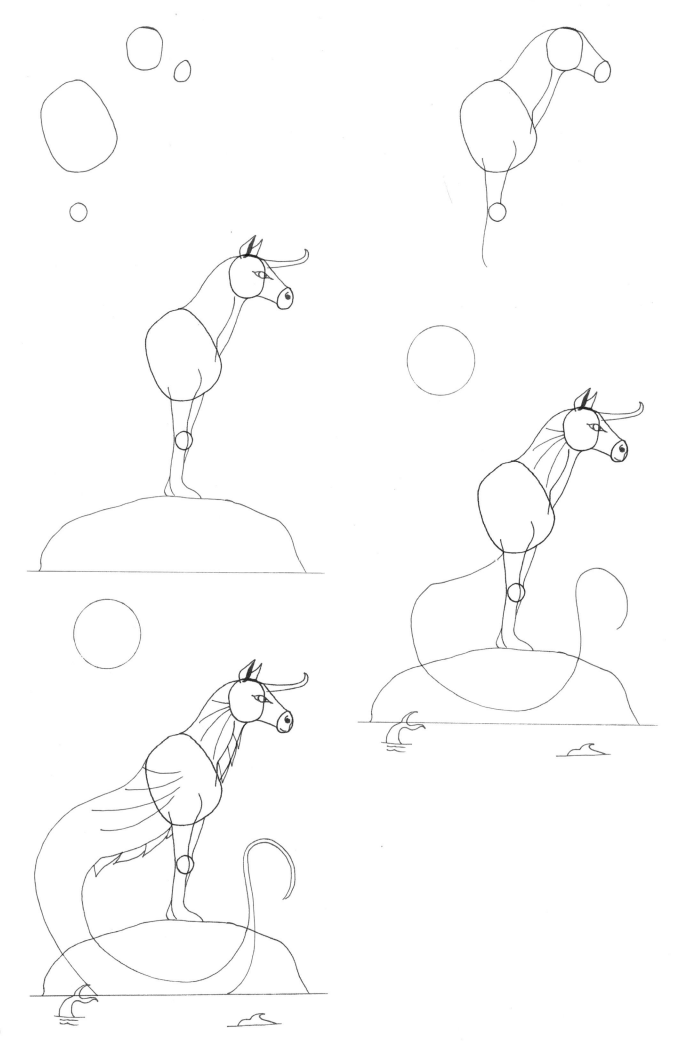

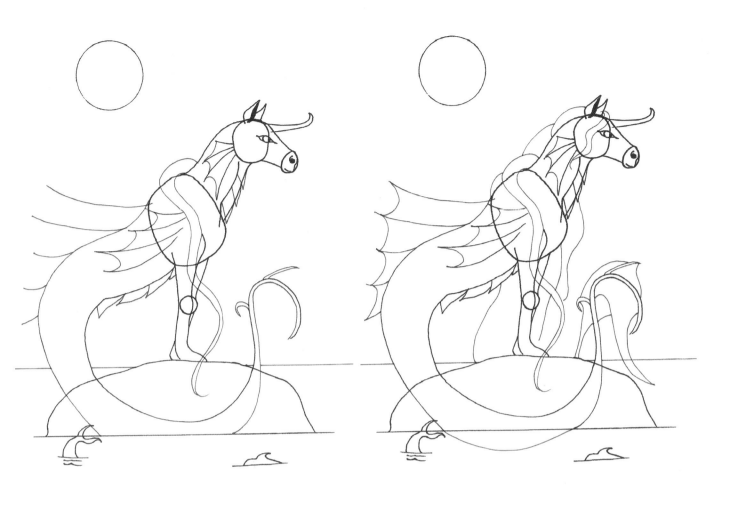

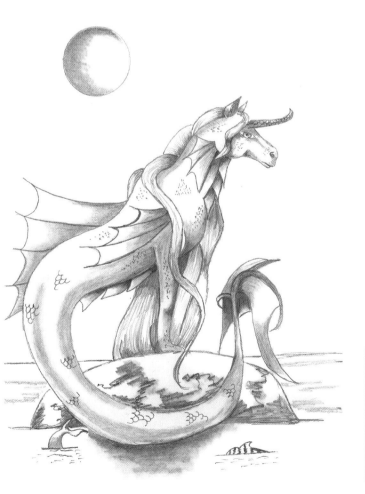

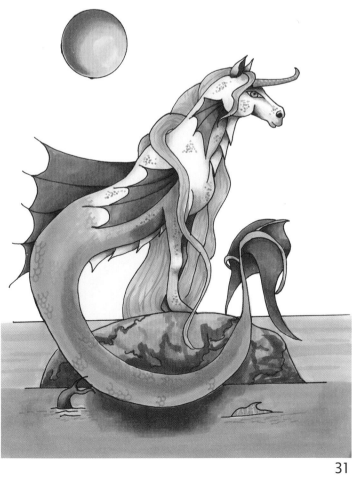

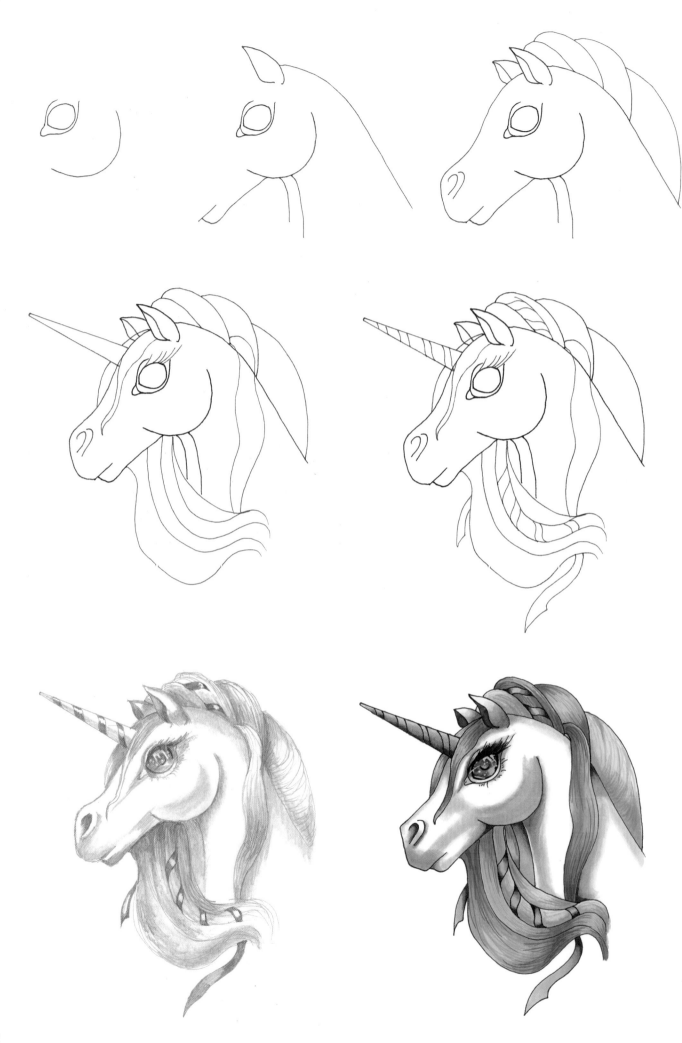